the Illustrated
Emily Dickinson
Nature Sketchbook

the Illustrated
Emily Dickinson
Nature Sketchbook

A Poetry-Inspired Drawing Journal

Illustrations by
Tara Lilly

QUARRY

Dedication

For kindred and poetic souls
who are also under nature's spell

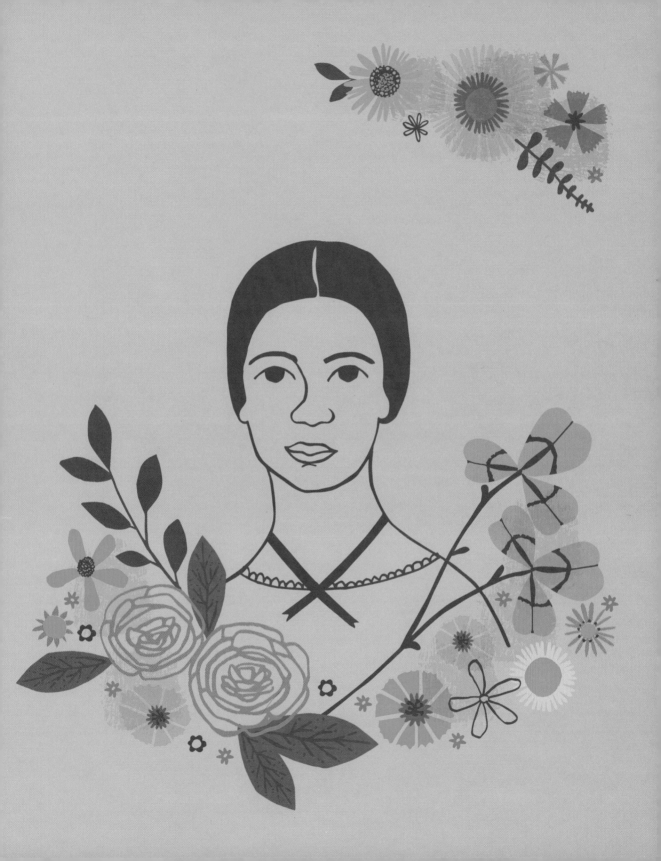

Introduction

"Even before she wrote poems, Dickinson was engaged in gathering, tending, categorizing, and pressing flowers. After writing poetry became her central preoccupation, cultivating bulbs, plants, and flowers within a portion of her father's land and in the glass enclosure of a conservatory (built just for her), remained a favorite occupation. ... Indeed, to be a notable gardener was a much more acceptable avocation for mid-Victorian women (meant to be the angel of their house) than to be a poet."

—EXCERPT FROM *THE GARDENS OF EMILY DICKINSON*,
BY JUDITH FARR AND LOUISE CARTER.

Emily Dickinson (1830–1886) was a poet with an exceptional ability to distill "amazing sense" from "ordinary meanings," to borrow two phrases from one of her poems. Though fewer than a dozen poems of the over 1,800 she wrote were published during her lifetime, they are now considered among the finest in the English language.

Yet, much about her life and work is misunderstood. Though often portrayed as remote and reclusive, Emily Dickinson was an intellectually curious, prolific, and driven artist. She shared poems with trusted family members and friends, much of it through correspondences. Her spare and brilliant poems vividly capture a range of experiences, from the blissful moments of a changing season to ponderous questions on love and immortality.

Emily was an avid gardener from a young age. She cultivated plants year-round in the conservatory that her father added to their homestead in Amherst, Massachusetts. She compiled an extensive herbarium of over 400 pressed plants, each carefully labeled, which is now in the collection of the Houghton Library at Harvard University. Flowers were not just a pastime, they were the lens through which she could examine truth, beauty, and the nature of living. Nature was both her passion and her muse.

This sketchbook is filled with fifty of Emily Dickinson's poems, interspersed with inspiring illustrations by the artist Tara Lilly. The open pages are for you to add your own musings and sketches inspired by the poems or by your own wanderings and reflections.

Enjoy!

A Day

I'LL TELL YOU HOW the sun rose, —
A ribbon at a time.
The steeples swam in amethyst,
The news like squirrels ran.

The hills untied their bonnets,
The bobolinks begun.
Then I said softly to myself,
"That must have been the sun!"

But how he set, I know not.
There seemed a purple stile
Which little yellow boys and girls
Were climbing all the while

Till when they reached the other side,
A dominie in gray
Put gently up the evening bars,
And led the flock away.

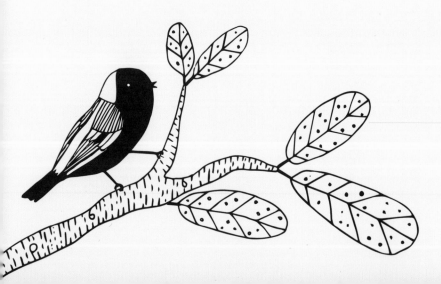

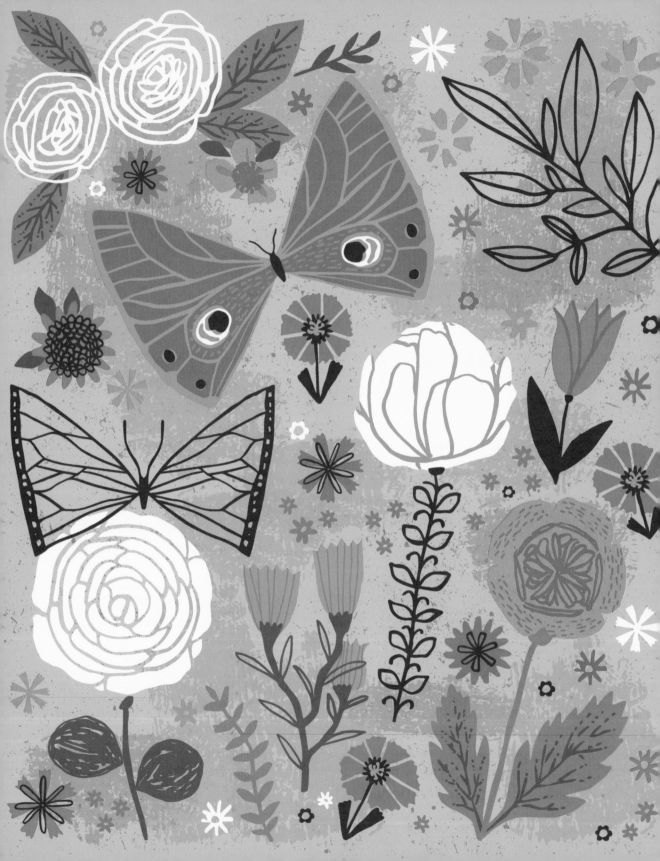

The Butterfly's Day

FROM COCOON FORTH a butterfly
As lady from her door
Emerged—a summer afternoon—
Repairing everywhere,

Without design, that I could trace,
Except to stray abroad
On miscellaneous enterprise
The clovers understood.

Her pretty parasol was seen
Contracting in a field
Where men made hay, then struggling hard
With an opposing cloud,

Where parties, phantom as herself,
To nowhere seemed to go
In purposeless circumference,
As 't were a tropic show.

And notwithstanding bee that worked,
And flower that zealous blew,
This audience of idleness
Disdained them, from the sky,

Till sundown crept, a steady tide,
And men that made the hay,
And afternoon, and butterfly,
Extinguished in its sea.

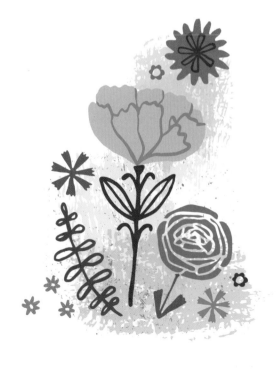

Purple Clover

THERE IS A FLOWER that bees prefer,
And butterflies desire;
To gain the purple democrat
The humming-birds aspire.

And whatsoever insect pass,
A honey bears away
Proportioned to his several dearth
And her capacity.

Her face is rounder than the moon,
And ruddier than the gown
Of orchis in the pasture,
Or rhododendron worn.

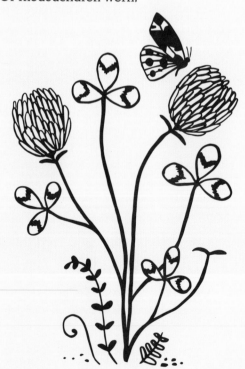

She doth not wait for June;
Before the world is green
Her sturdy little countenance
Against the wind is seen,
Contending with the grass,
Near kinsman to herself,
For privilege of sod and sun,
Sweet litigants for life.

And when the hills are full,
And newer fashions blow,
Doth not retract a single spice
For pang of jealousy.

Her public is the noon,
Her providence the sun,
Her progress by the bee proclaimed
In sovereign, swerveless tune.

The bravest of the host,
Surrendering the last,
Nor even of defeat aware
When cancelled by the frost.

May-Flower

PINK, SMALL, and punctual,
Aromatic, low,
Covert in April,
Candid in May,

Dear to the moss,
Known by the knoll,
Next to the robin
In every human soul.

Bold little beauty,
Bedecked with thee,
Nature forswears
Antiquity.

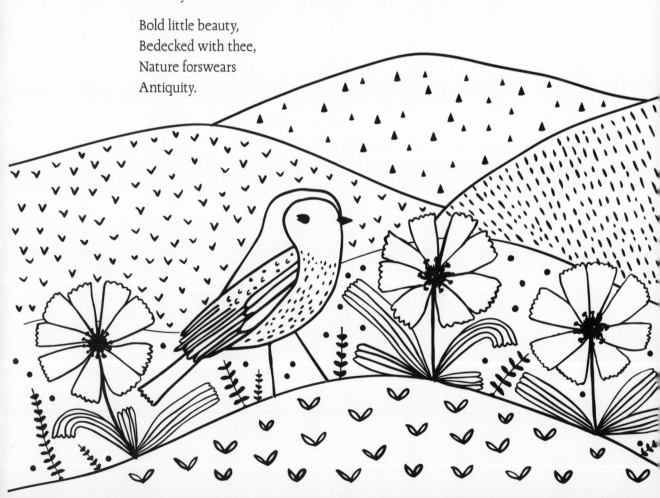

Two Voyagers

TWO BUTTERFLIES went out at noon
And waltzed above a stream,
Then stepped straight through the firmament
And rested on a beam;

And then together bore away
Upon a shining sea, —
Though never yet, in any port,
Their coming mentioned be.

If spoken by the distant bird,
If met in ether sea
By frigate or by merchantman,
Report was not to me.

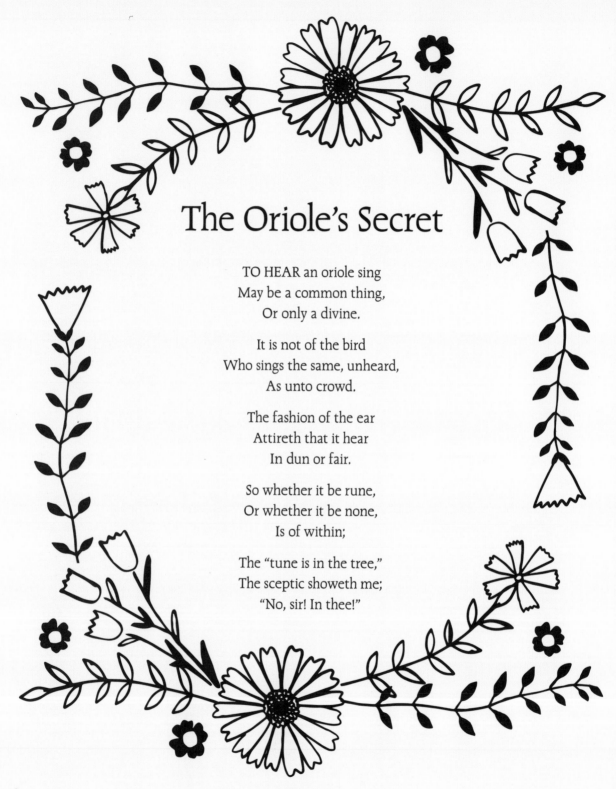

The Oriole's Secret

TO HEAR an oriole sing
May be a common thing,
Or only a divine.

It is not of the bird
Who sings the same, unheard,
As unto crowd.

The fashion of the ear
Attireth that it hear
In dun or fair.

So whether it be rune,
Or whether it be none,
Is of within;

The "tune is in the tree,"
The sceptic showeth me;
"No, sir! In thee!"

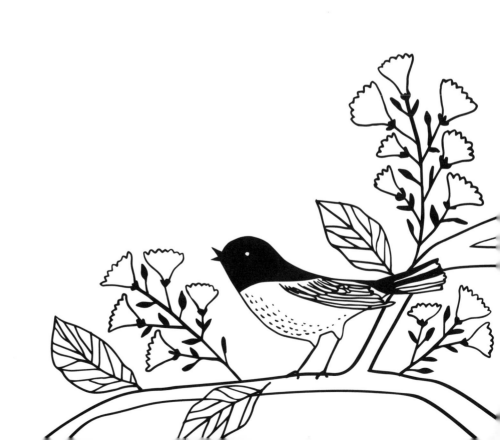

The Mushroom

THE MUSHROOM is the elf of plants,
At evening it is not;
At morning in a truffled hut
It stops upon a spot

As if it tarried always;
And yet its whole career
Is shorter than a snake's delay,
And fleeter than a tare.

'T is vegetation's juggler,
The germ of alibi;
Doth like a bubble antedate,
And like a bubble hie.

I feel as if the grass were pleased
To have it intermit;
The surreptitious scion
Of summer's circumspect.

Had nature any outcast face,
Could she a son contemn,
Had nature an Iscariot,
That mushroom, — it is him.

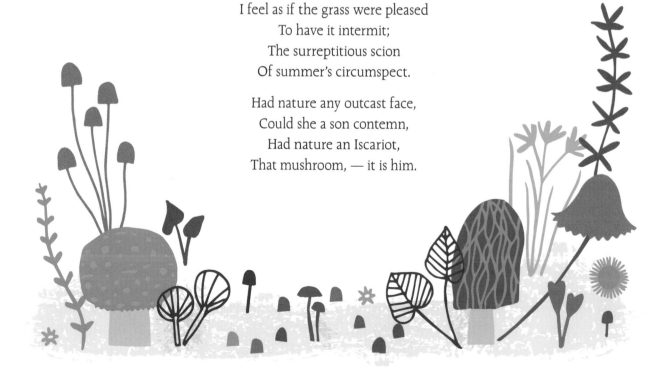

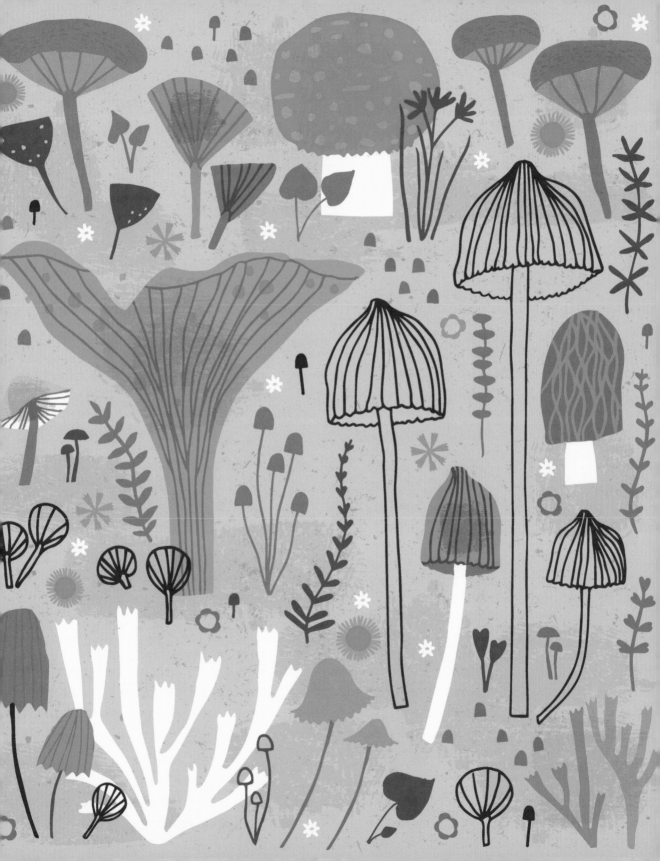

Gossip

THE LEAVES, like women, interchange
Sagacious confidence;
Somewhat of nods, and somewhat of
Portentous inference,

The parties in both cases
Enjoining secrecy, —
Inviolable compact
To notoriety.

The Tulip

SHE SLEPT beneath a tree
Remembered but by me.
I touched her cradle mute;
She recognized the foot,
Put on her carmine suit, —
And see!

She Sweeps with Many-Colored Brooms

SHE SWEEPS with many-colored brooms,
And leaves the shreds behind;
Oh, housewife in the evening west,
Come back, and dust the pond!

You dropped a purple ravelling in,
You dropped an amber thread;
And now you've littered all the East
With duds of emerald!

And still she plies her spotted brooms,
And still the aprons fly,
Till brooms fade softly into stars —
And then I come away.

April

AN ALTERED look about the hills;
A Tyrian light the village fills;
A wider sunrise in the dawn;
A deeper twilight on the lawn;
A print of a vermilion foot;
A purple finger on the slope;
A flippant fly upon the pane;
A spider at his trade again;
An added strut in chanticleer;
A flower expected everywhere;
An axe shrill singing in the woods;
Fern-odors on untravelled roads, —
All this, and more I cannot tell,
A furtive look you know as well,
And Nicodemus' mystery
Receives its annual reply.

The Moon

THE MOON was but a chin of gold
 A night or two ago,
And now she turns her perfect face
 Upon the world below.

Her forehead is of amplest blond;
 Her cheek like beryl stone;
Her eye unto the summer dew
 The likest I have known.

Her lips of amber never part;
 But what must be the smile
Upon her friend she could bestow
 Were such her silver will!

And what a privilege to be
 But the remotest star!
For certainly her way might pass
 Beside your twinkling door.

Her bonnet is the firmament,
 The universe her shoe,
The stars the trinkets at her belt,
 Her dimities of blue.

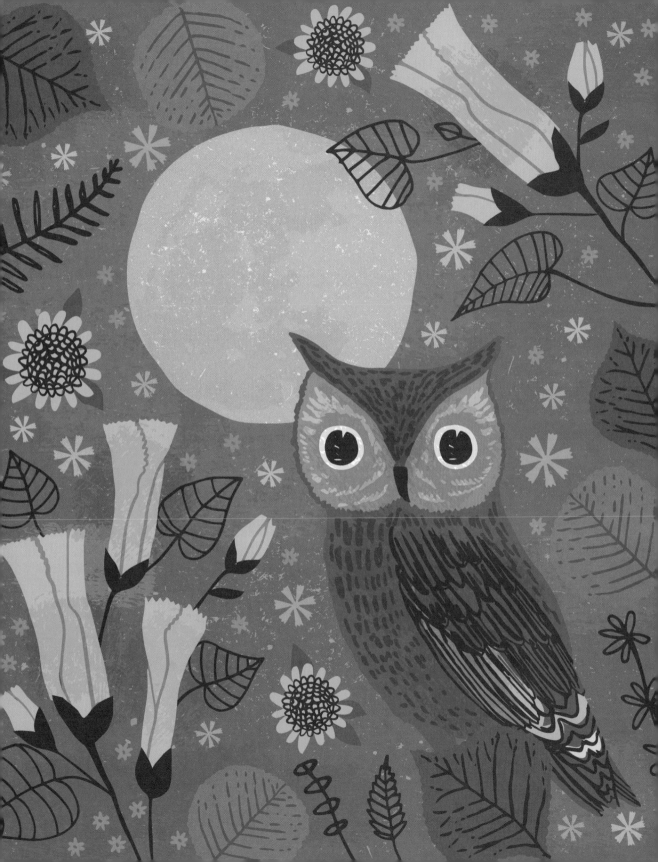

High from the Earth
I Heard a Bird

HIGH FROM THE EARTH I heard a bird;
He trod upon the trees
As he esteemed them trifles,
And then he spied a breeze,
And situated softly
Upon a pile of wind
Which in a perturbation
Nature had left behind.
A joyous-going fellow
I gathered from his talk,
Which both of benediction
And badinage partook,
Without apparent burden,
I learned, in leafy wood
He was the faithful father
Of a dependent brood;
And this untoward transport
His remedy for care,—
A contrast to our respites.
How different we are!

In Lands I Never Saw, They Say

IN LANDS I NEVER SAW, they say,
Immortal Alps look down,
Whose bonnets touch the firmament,
Whose sandals touch the town, —

Meek at whose everlasting feet
A myriad daisies play.
Which, sir, are you, and which am I,
Upon an August day?

Could I but Ride Indefinite

COULD I BUT RIDE indefinite
As doth the meadow bee
And visit only where I liked
And no one visit me

And flirt all day with buttercups
And marry whom I may
And dwell a little everywhere
Or better, run away

With no police to follow
Or chase him if he do
Till he should jump peninsulas
To get away from me—

I said "But just to be a bee"
Upon a raft of air
And row in nowhere all day long
And anchor "off the bar"

What liberty! So captives deem
Who tight in dungeons are.

The Waking Year

A lady red upon the hill
Her annual secret keeps;
A lady white within the field
In placid lily sleeps!

The tidy breezes with their brooms
Sweep vale, and hill, and tree!
Prithee, my pretty housewives!
Who may expected be?

The neighbors do not yet suspect!
The woods exchange a smile —
Orchard, and buttercup, and bird —
In such a little while!

And yet how still the landscape stands,
How nonchalant the wood,
As if the resurrection
Were nothing very odd!

Nature's Changes

THE SPRINGTIME'S pallid landscape
Will glow like bright bouquet,
Though drifted deep in parian
The village lies to-day.

The lilacs, bending many a year,
With purple load will hang;
The bees will not forget the tune
Their old forefathers sang.

The rose will redden in the bog,
The aster on the hill
Her everlasting fashion set,
And covenant gentians frill,

Till summer folds her miracle
As women do their gown,
Or priests adjust the symbols
When sacrament is done.

I Know a Place Where Summer Strives

I KNOW A PLACE where summer strives
With such a practised frost,
She each year leads her daisies back,
Recording briefly, "Lost."

But when the south wind stirs the pools
And struggles in the lanes,
Her heart misgives her for her vow,
And she pours soft refrains

Into the lap of adamant,
And spices, and the dew,
That stiffens quietly to quartz,
Upon her amber shoe.

At Half-Past Three,
a Single Bird

AT HALF-PAST THREE, a single bird
Unto a silent sky
Propounded but a single term
Of cautious melody.

At half-past four, experiment
Had subjugated test,
And lo! her silver principle
Supplanted all the rest.

At half-past seven, element
Nor implement was seen,
And place was where the presence was,
Circumference between.

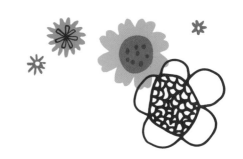

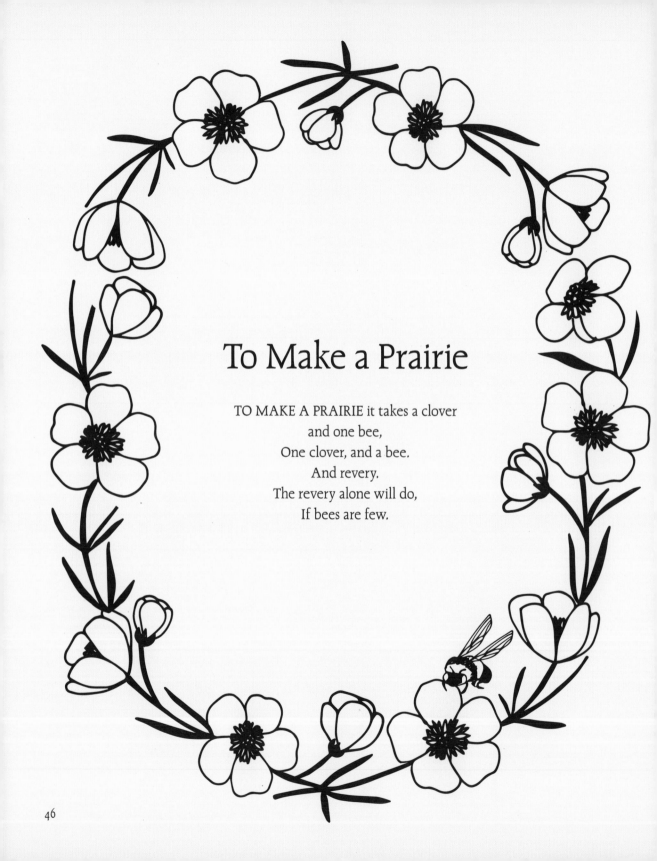

To Make a Prairie

TO MAKE A PRAIRIE it takes a clover
and one bee,
One clover, and a bee.
And revery.
The revery alone will do,
If bees are few.

The Wind

IT'S LIKE THE LIGHT, —
 A fashionless delight
It's like the bee, —
 A dateless melody.

It's like the woods,
 Private like breeze,
Phraseless, yet it stirs
 The proudest trees.

It's like the morning, —
 Best when it's done,
The everlasting clocks
 Chime noon.

To My Quick Ear
the Leaves Conferred

TO MY QUICK EAR the leaves — conferred —
The bushes — they were bells —
I could not find a privacy
From Nature's sentinels —

In cave if I presumed to hide
The walls — begun to tell —
Creation seemed a mighty crack —
To make me visible —

The Grass

THE GRASS so little has to do, —
A sphere of simple green,
With only butterflies to brood,
And bees to entertain,

And stir all day to pretty tunes
The breezes fetch along,
And hold the sunshine in its lap
And bow to everything;

And thread the dews all night, like pearls,
And make itself so fine, —
A duchess were too common
For such a noticing.

And even when it dies, to pass
In odors so divine,
As lowly spices gone to sleep,
Or amulets of pine.

And then to dwell in sovereign barns,
And dream the days away, —
The grass so little has to do,
I wish I were the hay!

The Sleeping Flowers

"WHOSE ARE THE LITTLE BEDS," I asked,
"Which in the valleys lie?"
Some shook their heads, and others smiled,
And no one made reply.

"Perhaps they did not hear," I said;
"I will inquire again.
Whose are the beds, the tiny beds
So thick upon the plain?"

"'T is daisy in the shortest;
A little farther on,
Nearest the door to wake the first,
Little leontodon.

"'T is iris, sir, and aster,
Anemone and bell,
Batschia in the blanket red,
And chubby daffodil."

Meanwhile at many cradles
Her busy foot she plied,
Humming the quaintest lullaby
That ever rocked a child.

"Hush! Epigea wakens! —
The crocus stirs her lids,
Rhodora's cheek is crimson, —
She's dreaming of the woods."

Then, turning from them, reverent,
"Their bed-time 't is," she said;
"The bumble-bees will wake them
When April woods are red."

Summer's Obsequies

THE GENTIAN weaves her fringes,
The maple's loom is red.
My departing blossoms
Obviate parade.

A brief, but patient illness,
An hour to prepare;
And one, below this morning,
Is where the angels are.

It was a short procession, —
The bobolink was there,
An aged bee addressed us,
And then we knelt in prayer.

We trust that she was willing, —
We ask that we may be.
Summer, sister, seraph,
Let us go with thee!

In the name of the bee
And of the butterfly
And of the breeze, amen!

In Shadow

I DREADED THAT first robin so,
But he is mastered now,
And I'm accustomed to him grown, —
He hurts a little, though.

I thought if I could only live
Till that first shout got by,
Not all pianos in the woods
Had power to mangle me.

I dared not meet the daffodils,
For fear their yellow gown
Would pierce me with a fashion
So foreign to my own.

I wished the grass would hurry,
So when 't was time to see,
He'd be too tall, the tallest one
Could stretch to look at me.

I could not bear the bees should come,
I wished they'd stay away
In those dim countries where they go:
What word had they for me?

They're here, though; not a creature failed,
No blossom stayed away
In gentle deference to me,
The Queen of Calvary.

Each one salutes me as he goes,
And I my childish plumes
Lift, in bereaved acknowledgment
Of their unthinking drums.

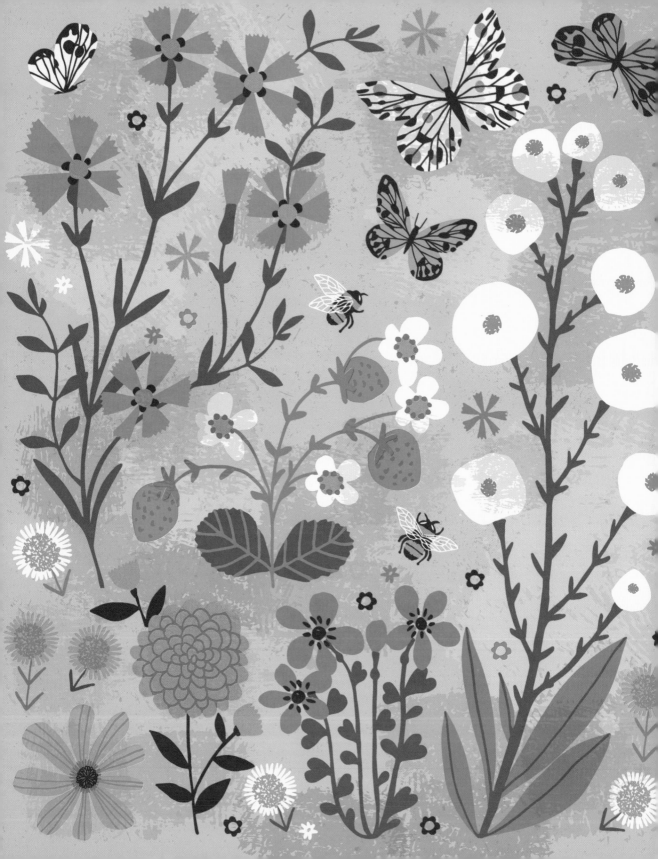

A Little Road Not Made of Man

A LITTLE ROAD not made of man,
Enabled of the eye,
Accessible to thill of bee,
Or cart of butterfly.

If town it have, beyond itself,
'T is that I cannot say;
I only sigh,—no vehicle
Bears me along that way.

The Sun's Wooing

THE SUN JUST touched the morning;
The morning, happy thing,
Supposed that he had come to dwell,
And life would be all spring.

She felt herself supremer, —
A raised, ethereal thing;
Henceforth for her what holiday!
Meanwhile, her wheeling king

Trailed slow along the orchards
His haughty, spangled hems,
Leaving a new necessity, —
The want of diadems!

The morning fluttered, staggered,
Felt feebly for her crown, —
Her unanointed forehead
Henceforth her only one.

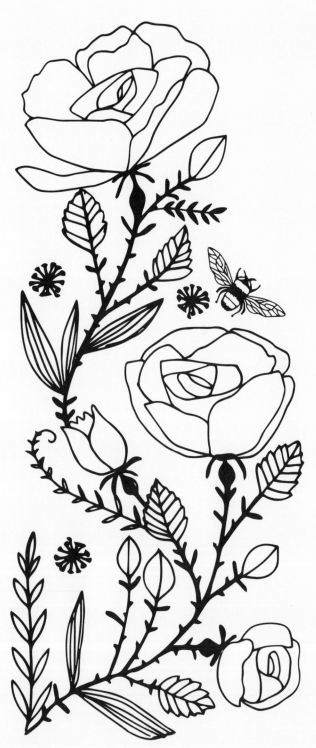

With a Flower

WHEN ROSES CEASE to bloom, dear,
And violets are done,
When bumble-bees in solemn flight
Have passed beyond the sun,

The hand that paused to gather
Upon this summer's day
Will idle lie, in auburn, —
Then take my flower, pray!

Evening

THE CRICKET sang,
And set the sun,
And workmen finished, one by one,
Their seam the day upon.

The low grass loaded with the dew,
The twilight stood as strangers do
With hat in hand, polite and new,
To stay as if, or go.

A vastness, as a neighbor, came, —
A wisdom without face or name,
A peace, as hemispheres at home, —
And so the night became.

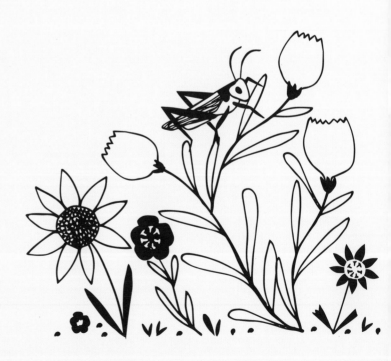

The Robin

THE ROBIN is the one
That interrupts the morn
With hurried, few, express reports
When March is scarcely on.

The robin is the one
That overflows the noon
With her cherubic quantity,
An April but begun.

The robin is the one
That speechless from her nest
Submits that home and certainty
And sanctity are best.

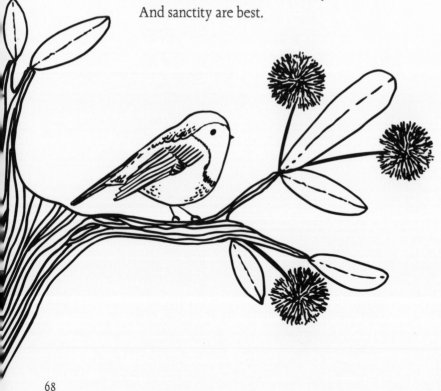

My Rose

PIGMY SERAPHS gone astray,
Velvet people from Vevay,
Belles from some lost summer day,
Bees' exclusive coterie.
Paris could not lay the fold
Belted down with emerald;
Venice could not show a cheek
Of a tint so lustrous meek.
Never such an ambuscade
As of brier and leaf displayed
For my little damask maid.
I had rather wear her grace
Than an earl's distinguished face;
I had rather dwell like her
Than be Duke of Exeter
Royalty enough for me
To subdue the bumble-bee!

Song

SUMMER FOR THEE grant I may be
When summer days are flown!
Thy music still when whippoorwill
And oriole are done!

For thee to bloom, I'll skip the tomb
And sow my blossoms o'er!
Pray gather me, Anemone,
Thy flower forevermore!

Transplanted

AS IF SOME little Arctic flower,
Upon the polar hem,
Went wandering down the latitudes,
Until it puzzled came
To continents of summer,
To firmaments of sun,
To strange, bright crowds of flowers,
And birds of foreign tongue!
I say, as if this little flower
To Eden wandered in —
What then? Why, nothing, only,
Your inference therefrom!

The Bee

LIKE TRAINS OF CARS on tracks of plush
I hear the level bee:
A jar across the flowers goes,
Their velvet masonry

Withstands until the sweet assault
Their chivalry consumes,
While he, victorious, tilts away
To vanquish other blooms.

His feet are shod with gauze,
His helmet is of gold;
His breast, a single onyx
With chrysoprase, inlaid.

His labor is a chant,
His idleness a tune;
Oh, for a bee's experience
Of clovers and of noon!

The Coming of Night

HOW THE OLD mountains drip
with sunset
How the hemlocks burn—
How the dun brake is draped in cinder
By the wizard sun—

How the old steeples hand the scarlet
Till the ball is full—
Have I the lip of the flamingo
That I dare to tell?

Then, how the fire ebbs like billows—
Touching all the grass
With a departing—sapphire—feature—
As a duchess passed—

How a small dusk crawls on the village
Till the houses blot
And the odd flambeau, no men carry
Glimmer on the street—

How it is night—in nest and kennel—
And where was the wood—
Just a dome of abyss is bowing
Into solitude—

These are the visions flitted Guido—
Titian—never told—
Domenichino dropped his pencil—
Paralyzed, with gold—

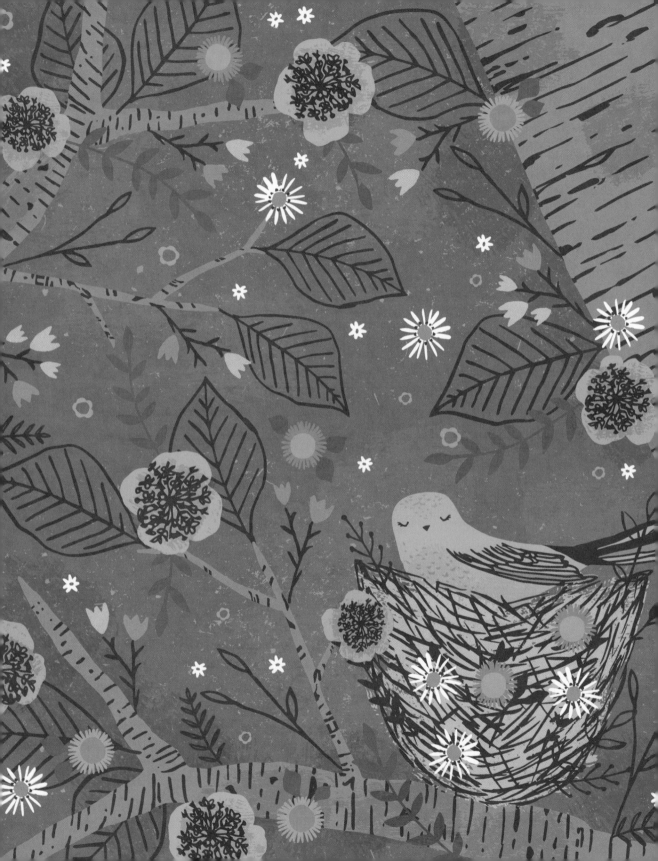

Loyalty

SPLIT THE LARK and you'll find the music,
 Bulb after bulb, in silver rolled,
Scantily dealt to the summer morning,
 Saved for your ear when lutes be old.

Loose the flood, you shall find it patent,
 Gush after gush, reserved for you;
Scarlet experiment! sceptic Thomas,
 Now, do you doubt that your bird was true?

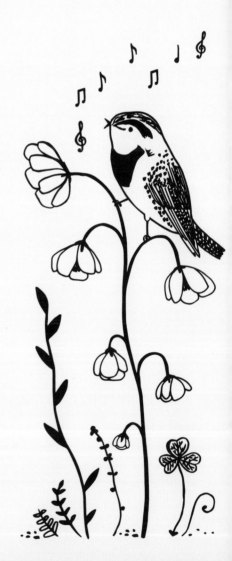

Secrets

THE SKIES CAN'T keep their secret!
They tell it to the hills —
The hills just tell the orchards —
And they the daffodils!

A bird, by chance, that goes that way
Soft overheard the whole.
If I should bribe the little bird,
Who knows but she would tell?

I think I won't, however,
It's finer not to know;
If summer were an axiom,
What sorcery had snow?

So keep your secret, Father!
I would not, if I could,
Know what the sapphire fellows do,
In your new-fashioned world!

Perhaps You'd Like to Buy a Flower?

PERHAPS YOU'D LIKE to buy a flower?
But I could never sell.
If you would like to borrow
Until the daffodil
Unties her yellow bonnet
Beneath the village door,
Until the bees, from clover rows
Their hock and sherry draw,
Why, I will lend until just then,
But not an hour more!

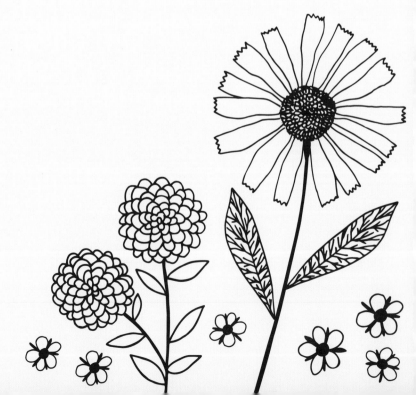

So Bashful When I Spied Her!

SO BASHFUL when I spied her!
So pretty—so ashamed!
So hidden in her leaflets
Lest anybody find—

So breathless till I passed here—
So helpless when I turned
And bore her struggling, blushing,
Her simple haunts beyond!

For whom I robbed the dingle—
For whom I betrayed the dell—
Many, will doubtless ask me,
But I shall never tell!

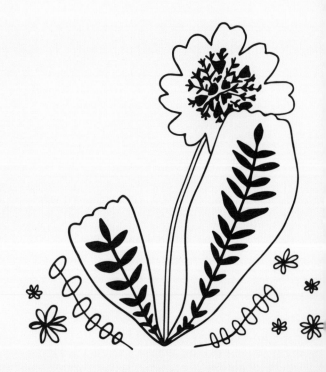

The Hummingbird

A ROUTE OF evanescence
With a revolving wheel;
A resonance of emerald,
A rush of cochineal;
And every blossom on the bush
Adjusts its tumbled head, —
The mail from Tunis, probably,
An easy morning's ride.

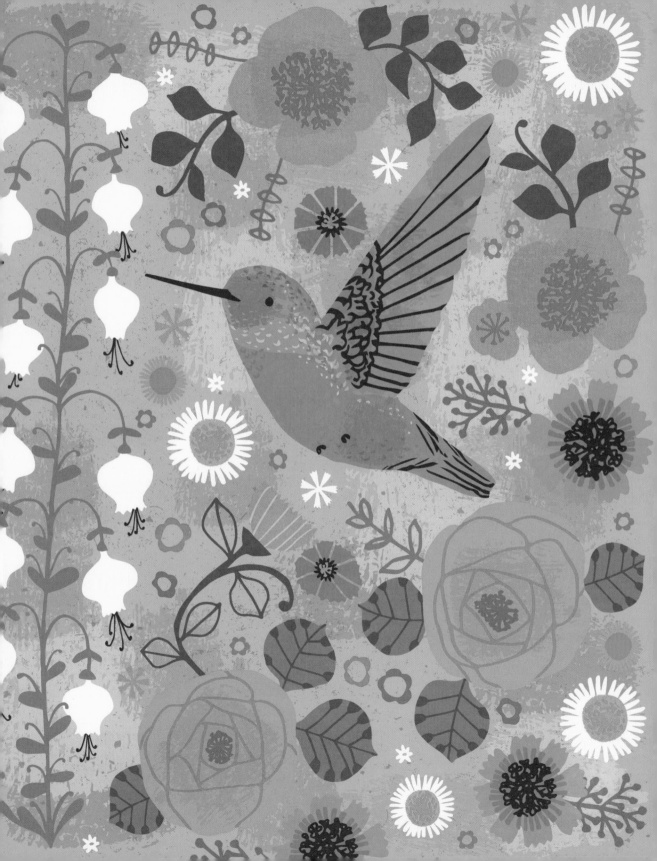

Two Worlds

IT MAKES NO difference abroad,
The seasons fit the same,
The mornings blossom into noons,
And split their pods of flame.

Wild-flowers kindle in the woods,
The brooks brag all the day;
No blackbird bates his jargoning
For passing Calvary.

Auto-da-fe and judgment
Are nothing to the bee;
His separation from his rose
To him seems misery.

The Bluebird

BEFORE YOU THOUGHT of spring,
Except as a surmise,
You see, God bless his suddenness,
A fellow in the skies
Of independent hues,
A little weather-worn,
Inspiriting habiliments
Of indigo and brown.

With specimens of song,
As if for you to choose,
Discretion in the interval,
With gay delays he goes
To some superior tree
Without a single leaf,
And shouts for joy to nobody
But his seraphic self!

By the Sea

I STARTED EARLY, took my dog,
And visited the sea;
The mermaids in the basement
Came out to look at me,

And frigates in the upper floor
Extended hempen hands,
Presuming me to be a mouse
Aground, upon the sands.

But no man moved me till the tide
Went past my simple shoe,
And past my apron and my belt,
And past my bodice too,

And made as he would eat me up
As wholly as a dew
Upon a dandelion's sleeve—
And then I started too.

And he — he followed close behind;
I felt his silver heel
Upon my ankle, — then my shoes
Would overflow with pearl.

Until we met the solid town,
No man he seemed to know;
And bowing with a mighty look
At me, the sea withdrew.

In the Garden

A BIRD CAME down the walk:
He did not know I saw;
He bit an angle-worm in halves
And ate the fellow, raw.

And then he drank a dew
From a convenient grass,
And then hopped sidewise to the wall
To let a beetle pass.

He glanced with rapid eyes
That hurried all abroad, —
They looked like frightened beads, I thought
He stirred his velvet head

Like one in danger; cautious,
I offered him a crumb,
And he unrolled his feathers
And rowed him softer home

Than oars divide the ocean,
Too silver for a seam,
Or butterflies, off banks of noon,
Leap, plashless, as they swim.

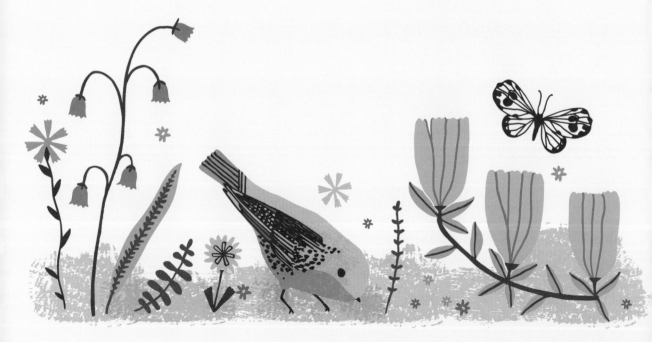

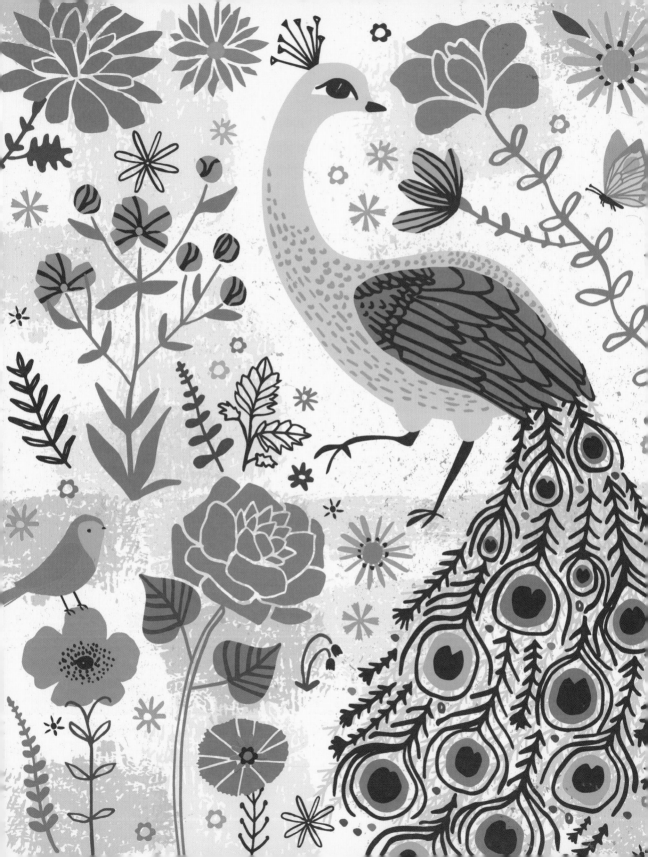

Summer's Armies

SOME RAINBOW coming from the fair!
Some vision of the world Cashmere
I confidently see!
Or else a peacock's purple train,
Feather by feather, on the plain
Fritters itself away!

The dreamy butterflies bestir,
Lethargic pools resume the whir
Of last year's sundered tune.
From some old fortress on the sun
Baronial bees march, one by one,
In murmuring platoon!

The robins stand as thick to-day
As flakes of snow stood yesterday,
On fence and roof and twig.
The orchis binds her feather on
For her old love, Don the Sun,
Revisiting the bog!

Without commander, countless, still,
The regiment of wood and hill
In bright detachment stand.
Behold! Whose multitudes are these?
The children of whose turbaned seas,
Or what Circassian land?

With Flowers

IF RECOLLECTING were forgetting,
Then I remember not;
And if forgetting, recollecting,
How near I had forgot!
And if to miss were merry,
And if to mourn were gay,
How very blithe the fingers
That gathered these to-day!

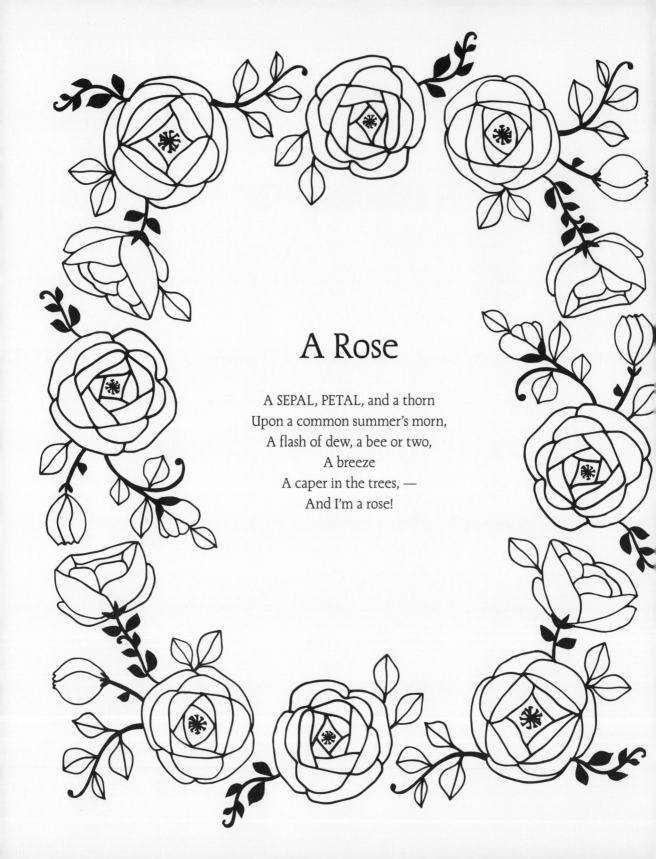

A Rose

A SEPAL, PETAL, and a thorn
Upon a common summer's morn,
A flash of dew, a bee or two,
A breeze
A caper in the trees, —
And I'm a rose!

Problems

BRING ME THE SUNSET in a cup,
Reckon the morning's flagons up,
And say how many dew;
Tell me how far the morning leaps,
Tell me what time the weaver sleeps
Who spun the breadths of blue!

Write me how many notes there be
In the new robin's ecstasy
Among astonished boughs;
How many trips the tortoise makes,
How many cups the bee partakes, —
The debauchee of dews!

Also, who laid the rainbow's piers,
Also, who leads the docile spheres
By withes of supple blue?
Whose fingers string the stalactite,
Who counts the wampum of the night,
To see that none is due?

Who built this little Alban house
And shut the windows down so close
My spirit cannot see?
Who'll let me out some gala day,
With implements to fly away,
Passing pomposity?

Mother Nature

NATURE, THE GENTLEST mother,
Impatient of no child,
The feeblest or the waywardest, —
Her admonition mild

In forest and the hill
By traveller is heard,
Restraining rampant squirrel
Or too impetuous bird.

How fair her conversation,
A summer afternoon, —
Her household, her assembly;
And when the sun goes down

Her voice among the aisles
Incites the timid prayer
Of the minutest cricket,
The most unworthy flower.

When all the children sleep
She turns as long away
As will suffice to light her lamps;
Then, bending from the sky

With infinite affection
And infiniter care,
Her golden finger on her lip,
Wills silence everywhere.

Index of Poems

These poems were selected from the following three volumes that are now in the public domain. They have been lightly edited for consistency and modern usage. First lines of untitled poems are in quotations; poem titles are in italic type.

Poems by Emily Dickinson, edited by Mabel Loomis Todd and T. W. Higginson, copyright 1890, by Roberts Brothers of Boston.

Poems, Second Series, by Emily Dickson, edited by T. W. Higginson and Mabel Loomis Todd, copyright 1891, by Roberts Brothers of Boston.

Poems, Third Series, by Emily Dickinson, edited by Mabel Loomis Todd, copyright 1896, by Roberts Brothers of Boston.

Resources

Emily Dickinson Museum
280 Main Street
Amherst, MA 01002
413-542-8161
www.emilydickinsonmuseum.org

*The two major repositories for Emily Dickinson's
manuscripts and family papers are
Amherst College and Harvard University.*

Amherst College Archives and
Special Collections
Amherst, MA 01002
413-542-2000
www.amherst.edu/library/archives/
holdings/edickinson

Houghton Library
Harvard University
Cambridge, MA 02138
617-495-2440
http:/hcl.harvard.edu/libraries/houghton

Acknowledgments

Thanks to Jane Wald, executive director of the Emily Dickinson
Museum, who generously shared information as I was developing
this project. The museum is a vast resource for additional
information on Emily Dickinson's life, her poetry, and collections.

Thanks also to Tara Lilly, whose charming illustrations grace
these pages.

Mary Ann Hall, editor

About the Illustrator

TARA LILLY grew up on family farmland in rural Northern California playing in the redwood forest. She moved to Portland, Oregon, to study graphic design and advertising at Portland State University. She now lives in Portland with her husband, Charles, and daughter, June. She has worked as a graphic designer and illustrator for stationery products, paper crafts, and products for a gift company.

She is the grand prize winner of the 2014 Lilla Rogers Global Talent Search, selected from nearly 1,000 entrants, and is now represented by Lilla Rogers Studio.

Tara is inspired by patterns in nature, old picture books, vintage floral motifs, folk art, and primitive art. Her art is filled with textures, bright colors, fun florals, and charming characters, created from fine-tipped ink pens, brush pens, india ink, charcoal, and more.

To see more of her work: www.taralilly.com

Quarto is the authority on a wide range of topics.

Quarto educates, entertains and enriches the lives of
our readers—enthusiasts and lovers of hands-on living.

www.QuartoKnows.com

© 2016 Quarto Publishing Group USA Inc.

First published in the United States of America in 2016 by
Quarry Books, an imprint of
Quarto Publishing Group USA Inc.
100 Cummings Center
Suite 406-L
Beverly, Massachusetts 01915-6101
Telephone: (978) 282-9590
Fax: (978) 283-2742
QuartoKnows.com
Visit our blogs at QuartoKnows.com

ISBN: 978-1-63159-123-5

Cover and Book Design: Kathie Alexander
All Illustration: © Tara Lilly

Printed and bound in China